APERTURE MASTERS OF PHOTOGRAPHY

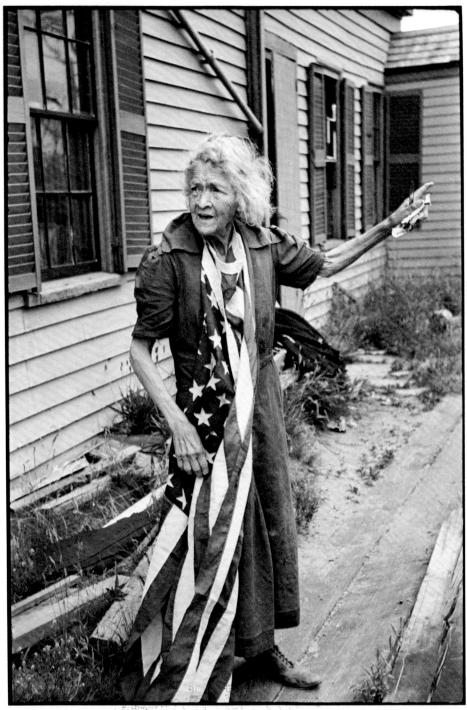

METANGELLE

HENRI CARTIER-BRESSON

APERTURE MASTERS OF PHOTOGRAPHY

NUMBER TWO
PROPERTY OF
CLACKAMAS COMMUNITY COLLEGE
LIBRARY

The Masters of Photography series is published by Aperture. *Henri Cartier-Bresson* is the second book in the series. The first edition was produced under the artistic direction of Robert Delpire.

Copyright © 1976, 1987 Aperture Foundation, Inc. Photographs © 1976 Henri Cartier-Bresson. Text © 1976 Henri Cartier-Bresson. All rights reserved under International and Pan-American Copyright Conventions.

Manufactured in Hong Kong. Stonetone® negatives by Rapoport Printing Corp., New York.

Series design by Alan Richardson.

Library of Congress Catalog Number: 87-70205. ISBN: 0-89381-281-1 (cloth edition). ISBN: 0-89381-265-x (paperback edition).

Aperture Foundation Inc. publishes a periodical, books, and portfolios of fine photography to communicate with serious photographers everywhere. A complete catalog is available upon request. Address: 20 East 23 Street, New York, New York 10010.

"Actually it's quite true that he's not waiting for anyone since he's not made any appointment, but the very fact that he's adopting this ultra-receptive posture means that by this he wants to help chance along, how should I say, to put himself in a state of grace with chance, so that something might happen, so that some one might drop in."

> —André Breton, Entretiens (1913–1952) (Idées/Gallimard, p. 150)

Photography has not changed since its origin except in its technical aspects, which for me are not a major concern.

Photography appears to be an easy activity; in fact, it is a varied and ambiguous process in which the only common denominator among its practitioners is their instrument. What emerges from this recording machine does not escape the economic constraints of a world of waste, of tensions that become increasingly intense and of insane ecological consequences.

"Manufactured" or staged photography does not concern me. And if I make a judgment, it can only be on a psychological or sociological level. There are those who take photographs arranged beforehand and those who go out to discover the image and seize it. For me, the camera is a sketch book, an instrument of intuition and spontaneity, the master of the instant which—in visual terms—questions and decides simultaneously. In order to "give a meaning" to the world, one has to feel oneself involved in what he frames through the viewfinder. This attitude requires concentration, a discipline of mind, sensitivity, and a sense of geometry. It is by great economy of means that one arrives at simplicity of expression. One must always take photos with the greatest respect for the subject and for oneself.

To take photographs is to hold one's breath when all faculties converge in the face of fleeing reality. It is at that moment that mastering an image becomes a great physical and intellectual joy.

To take photographs means to recognize—simultaneously and within a fraction of a second—both the fact itself and the rigorous organization of visually perceived forms that give it meaning. It is putting one's head, one's eye and one's heart on the same axis.

As far as I am concerned, taking photographs is a means of understanding which cannot be separated from other means of visual expression. It is a way of shouting, of freeing oneself, not of proving or asserting one's own originality. It is a way of life.

Henri Cartier-Bresson

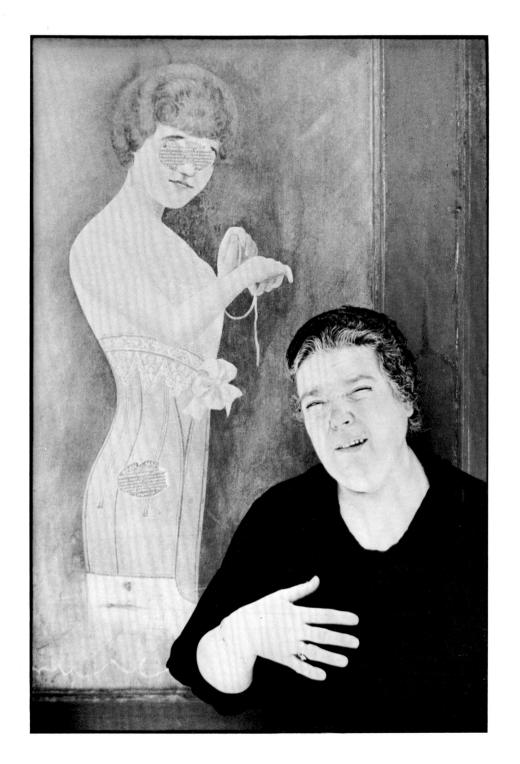

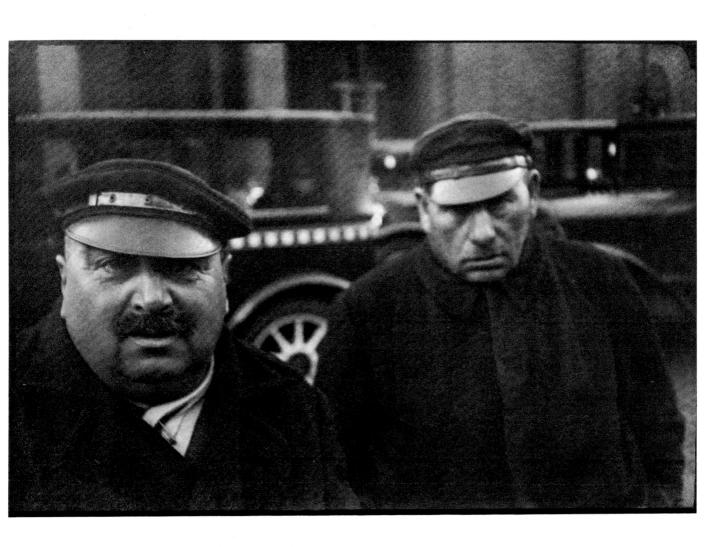

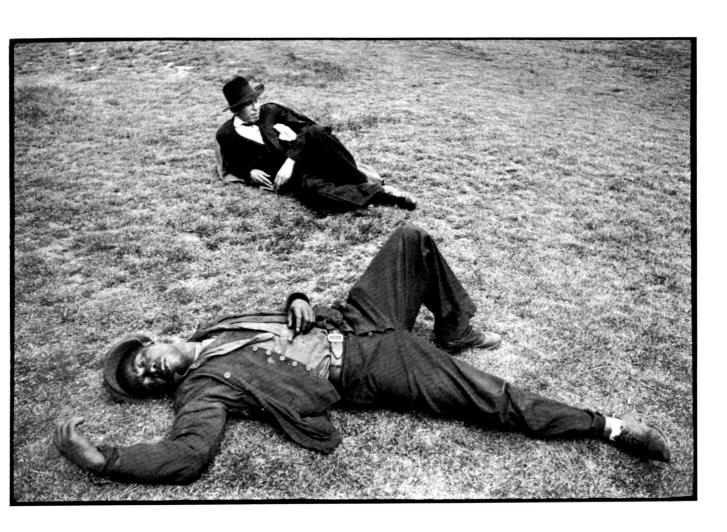

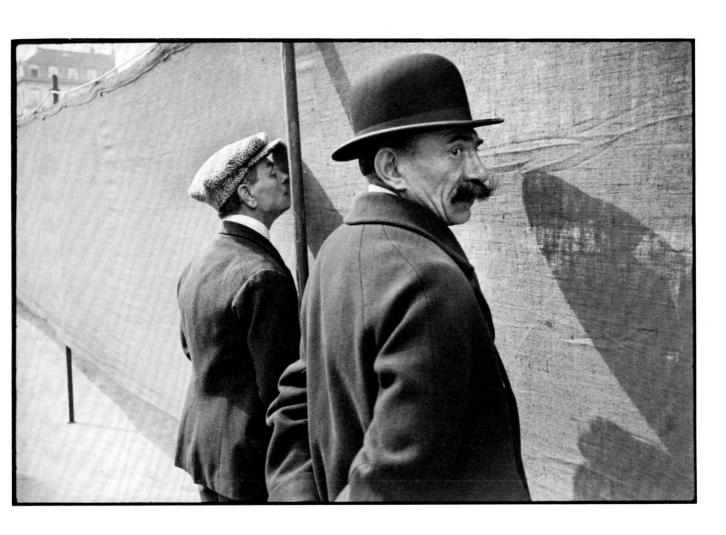

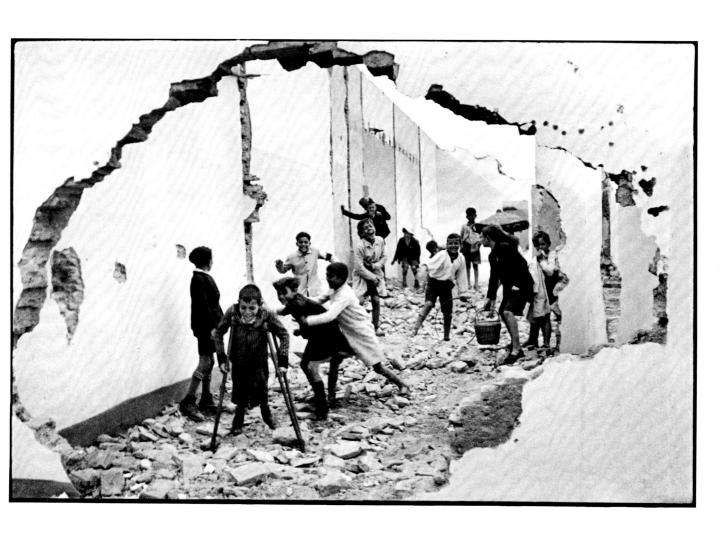

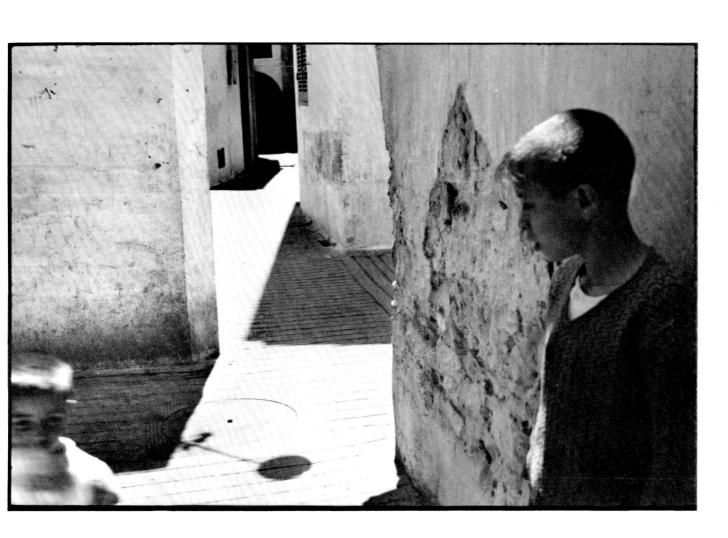

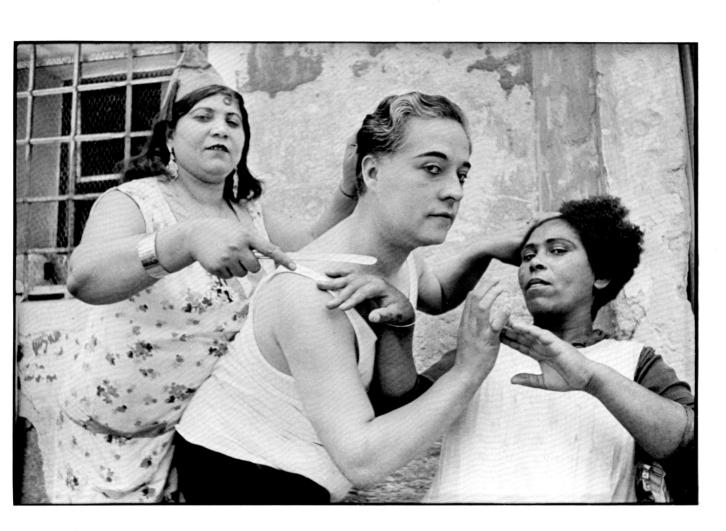

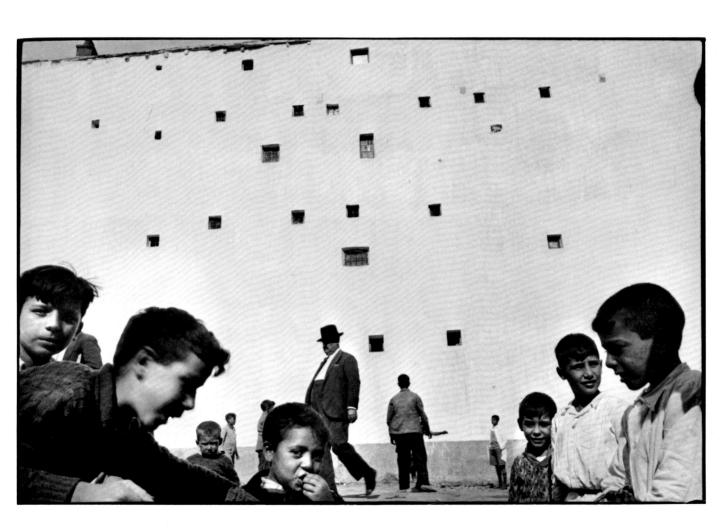

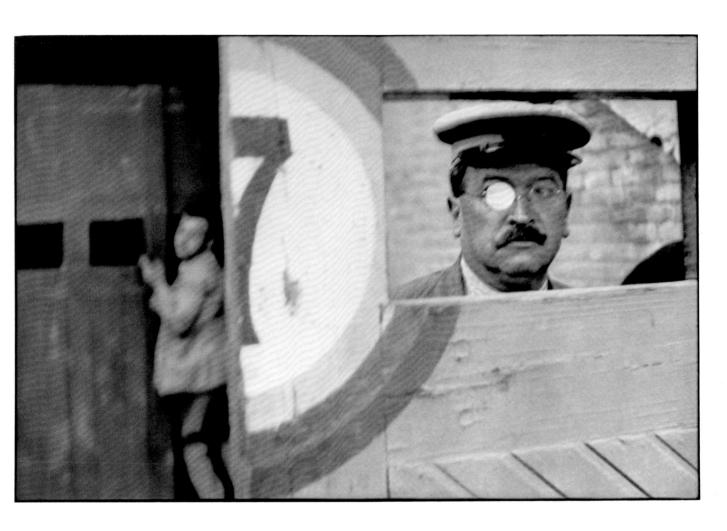

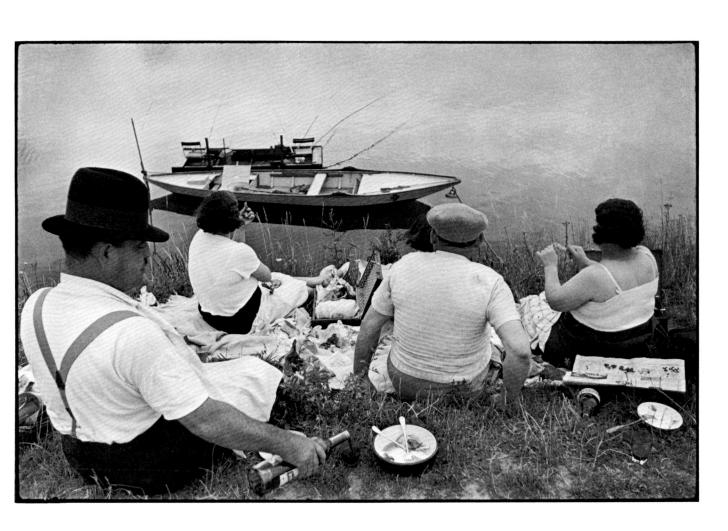

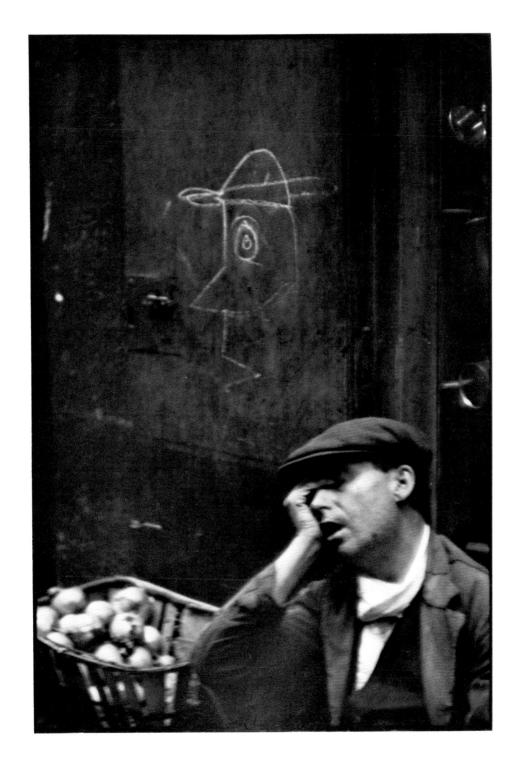

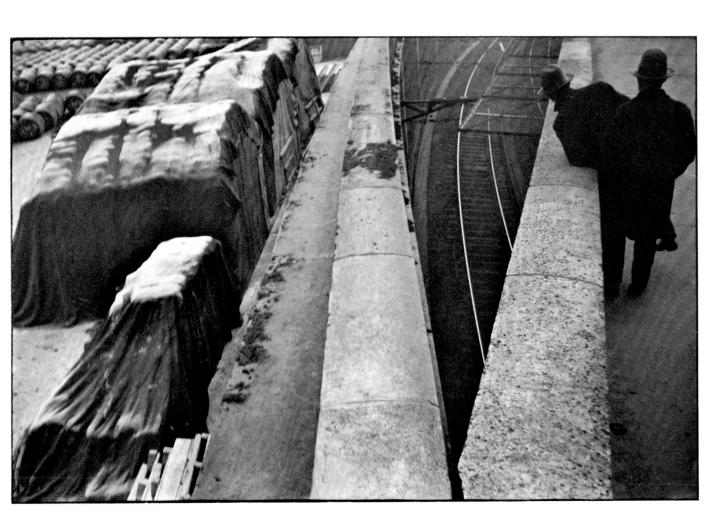

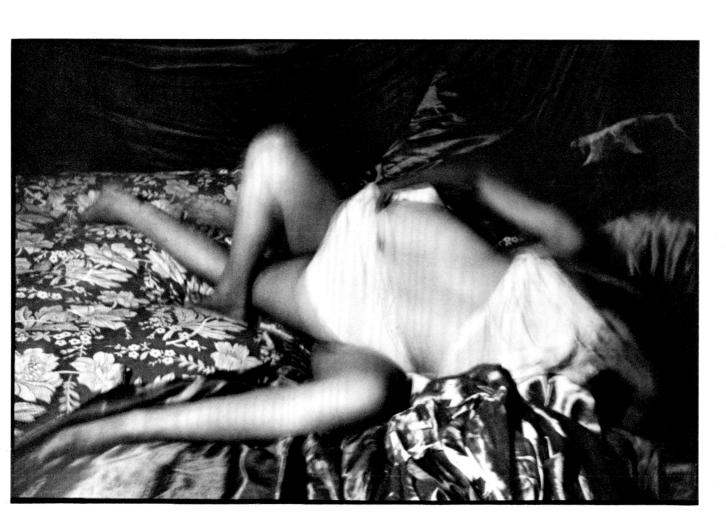

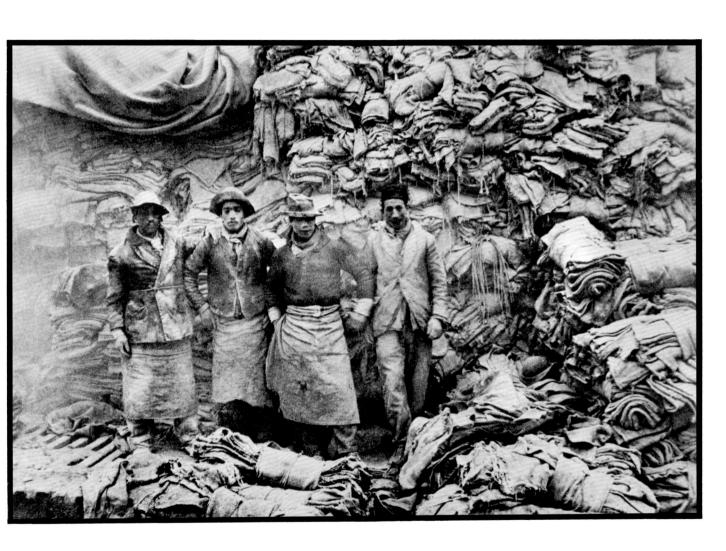

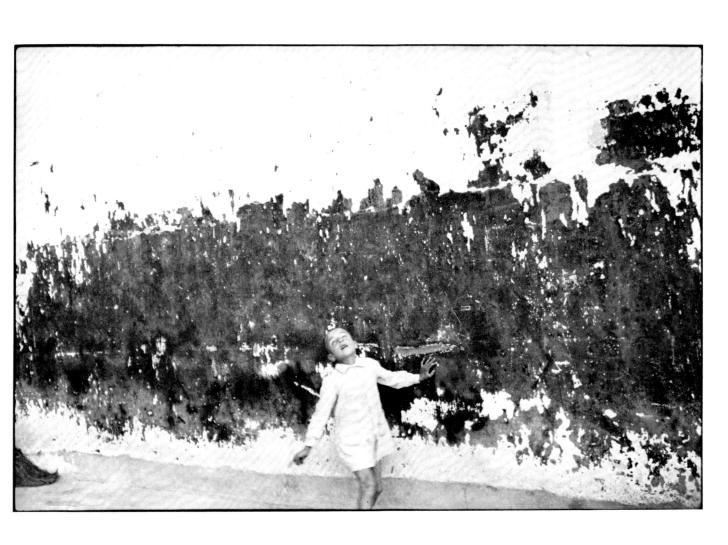

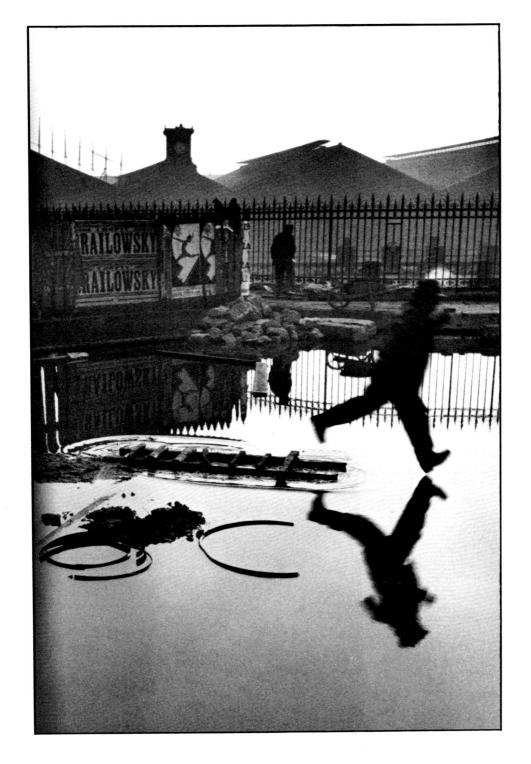

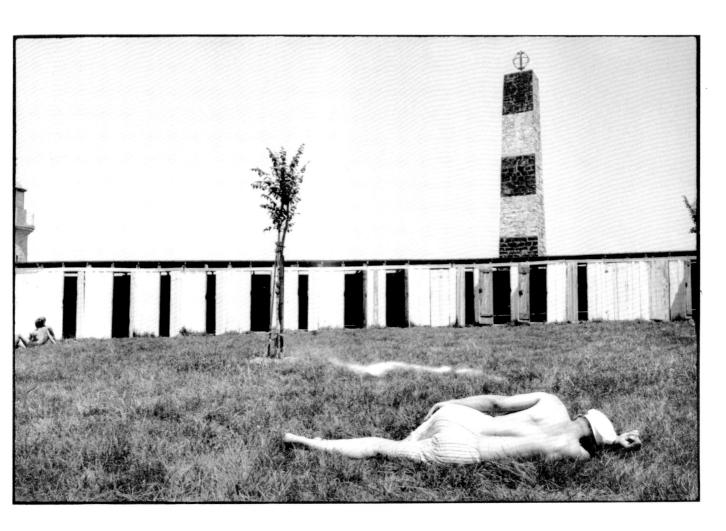

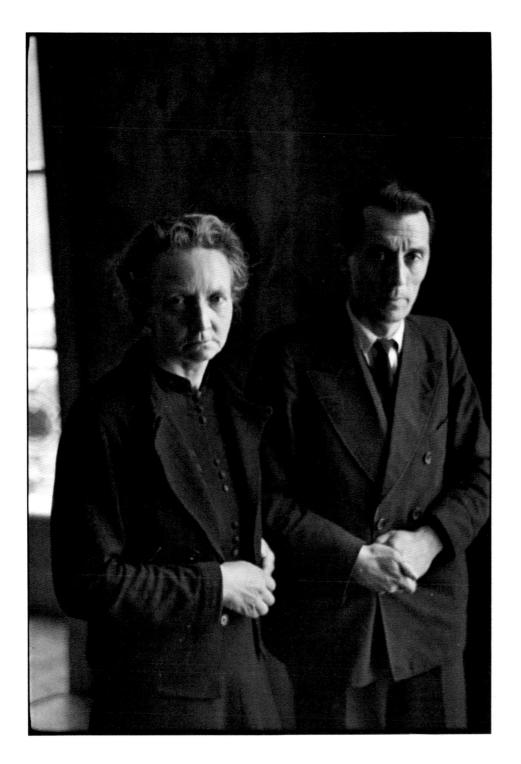

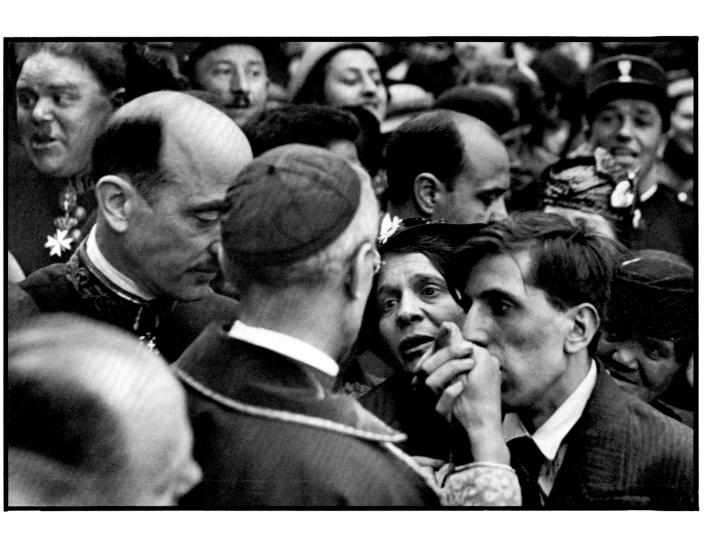

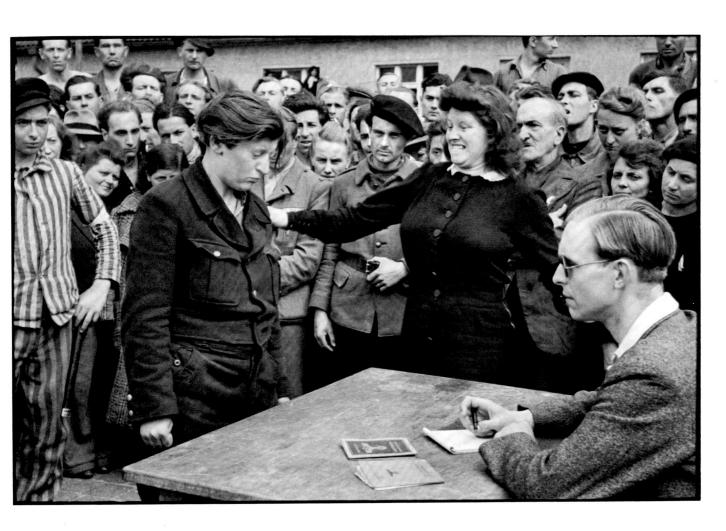

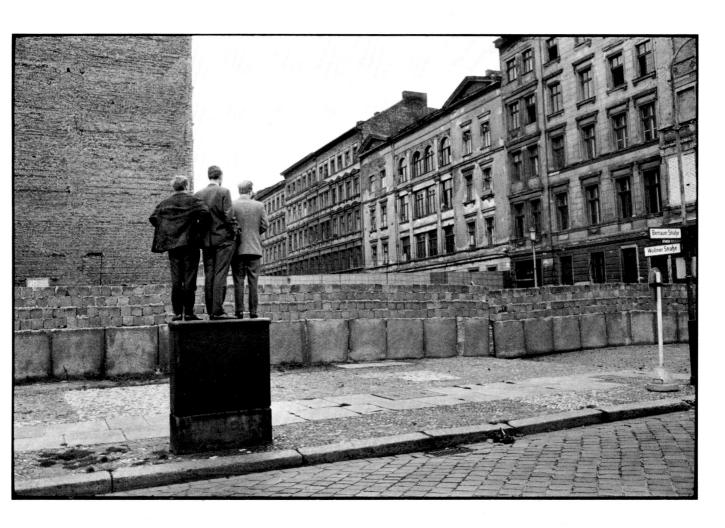

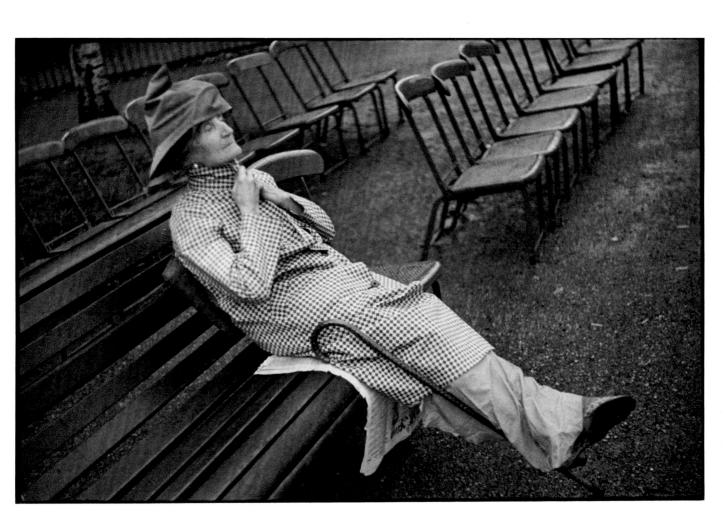

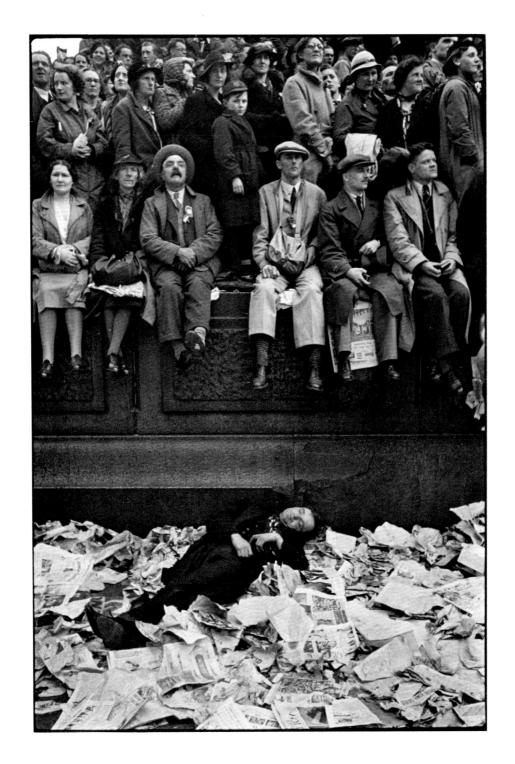

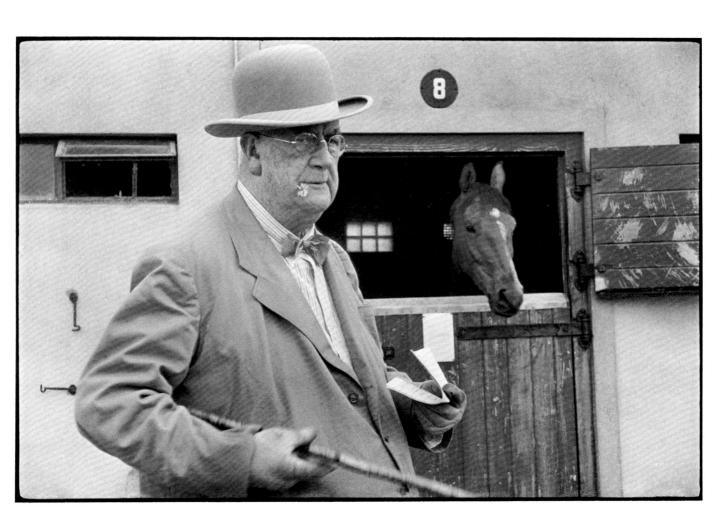

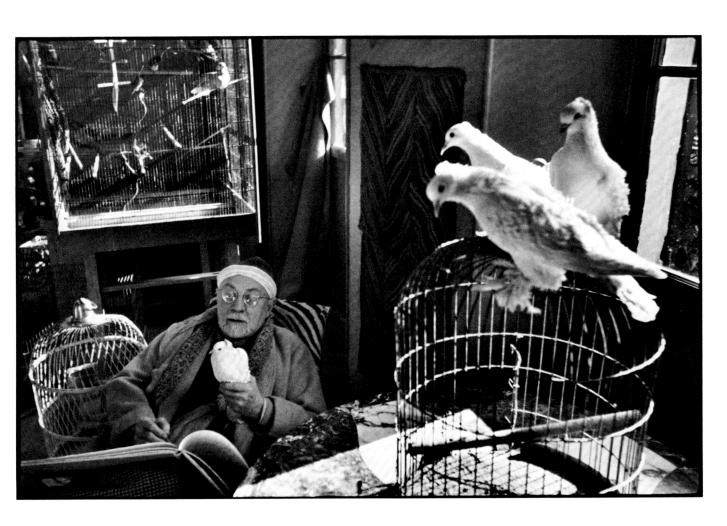

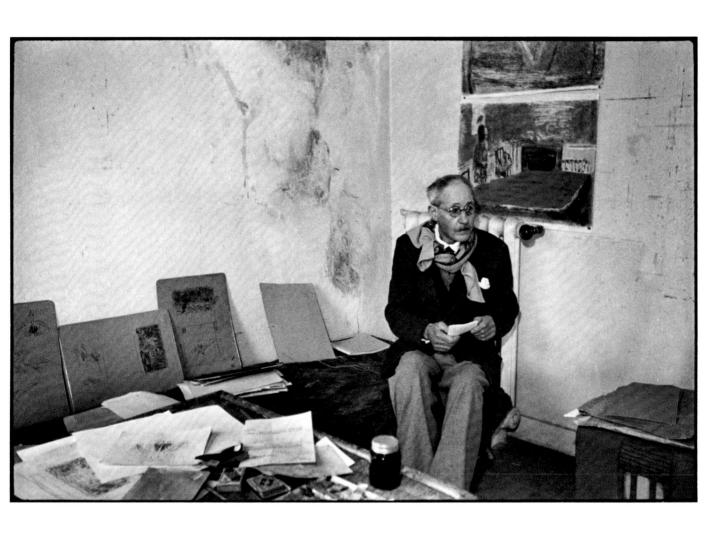

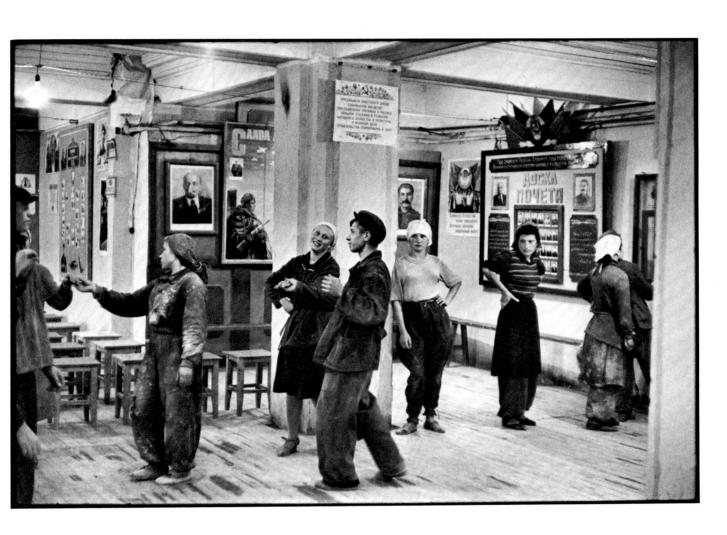

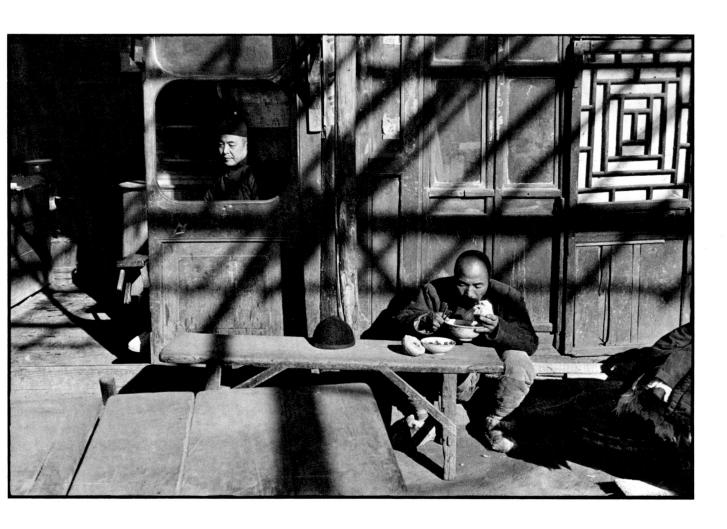

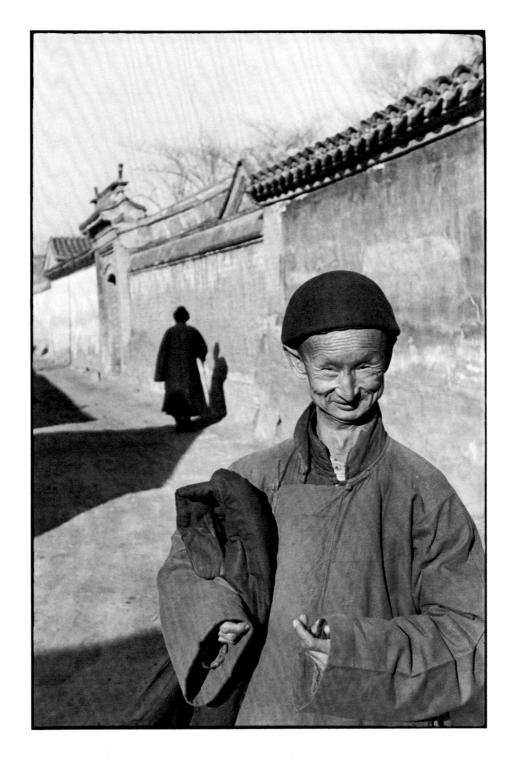

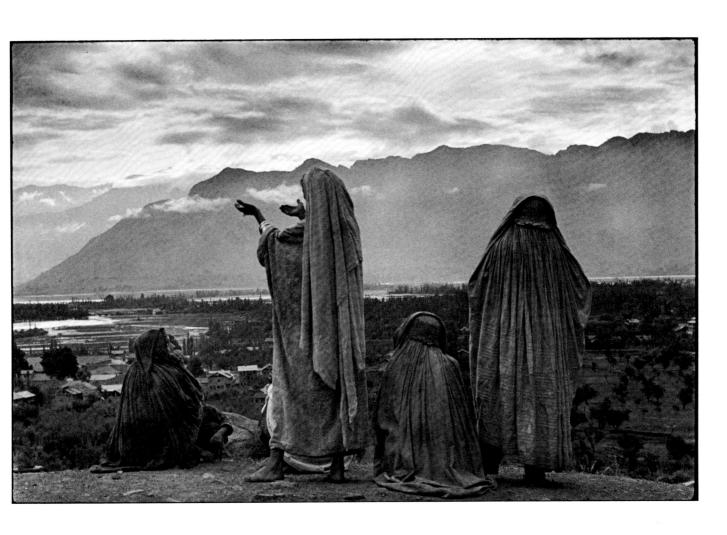

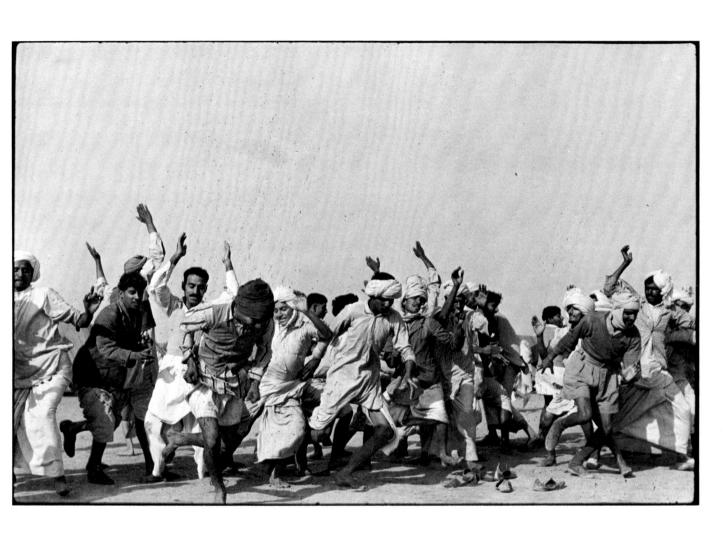

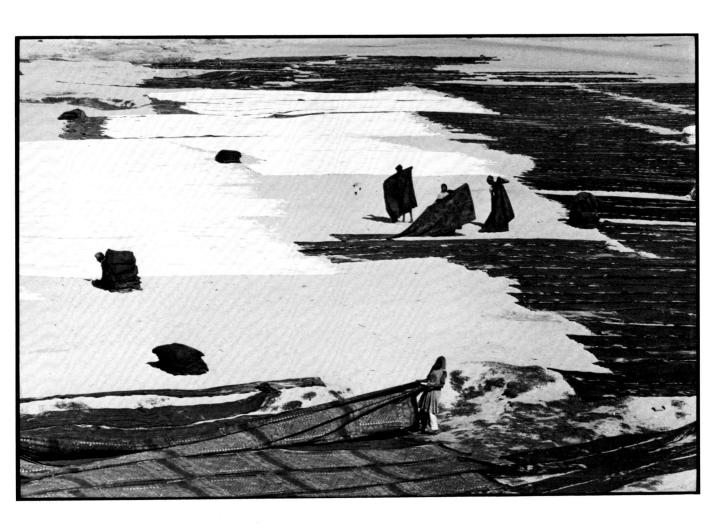

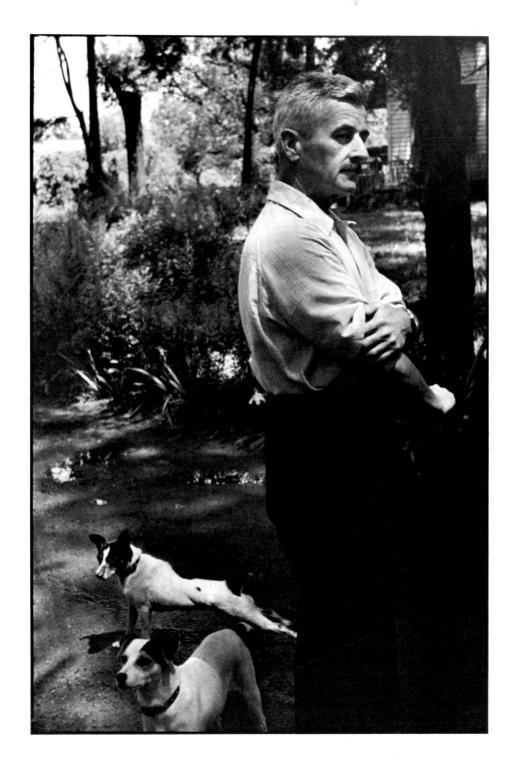

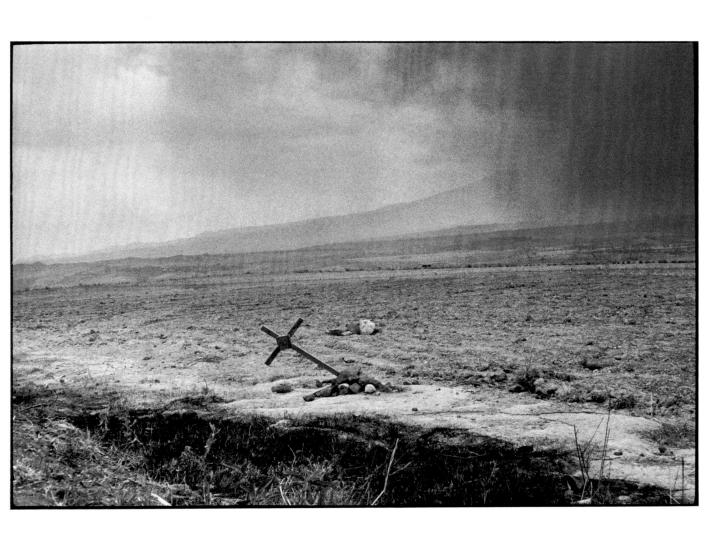

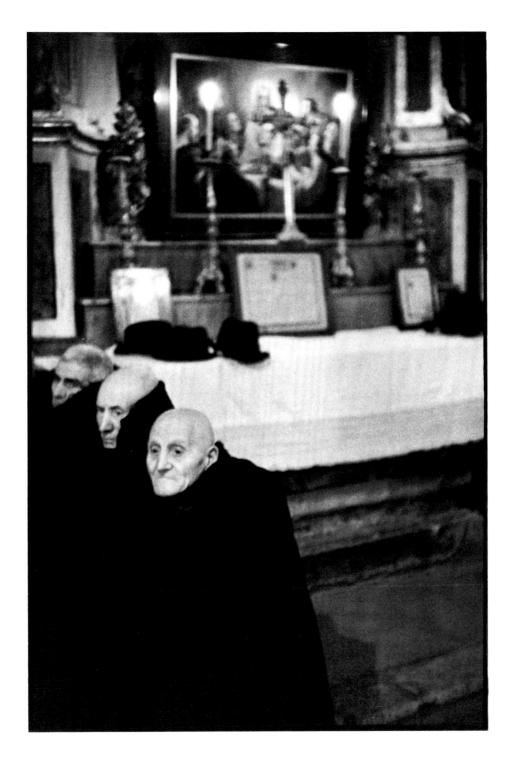

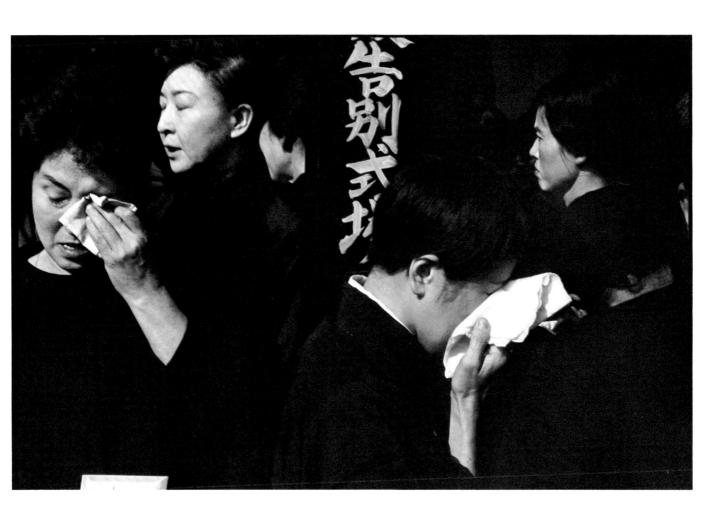

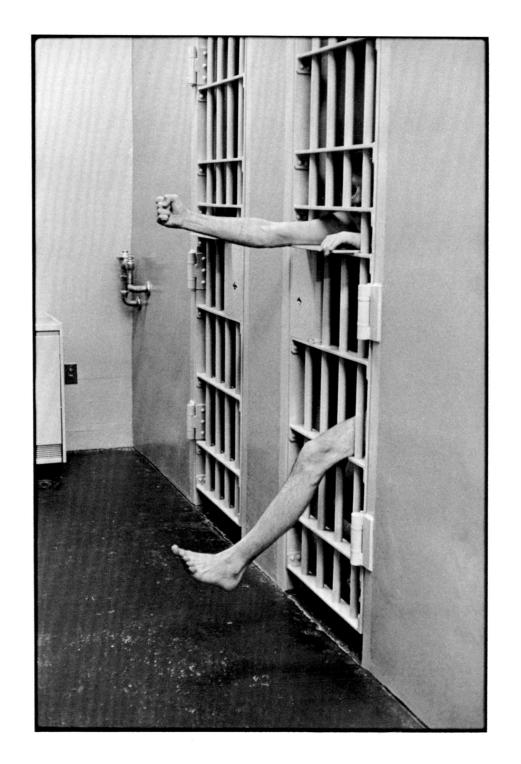

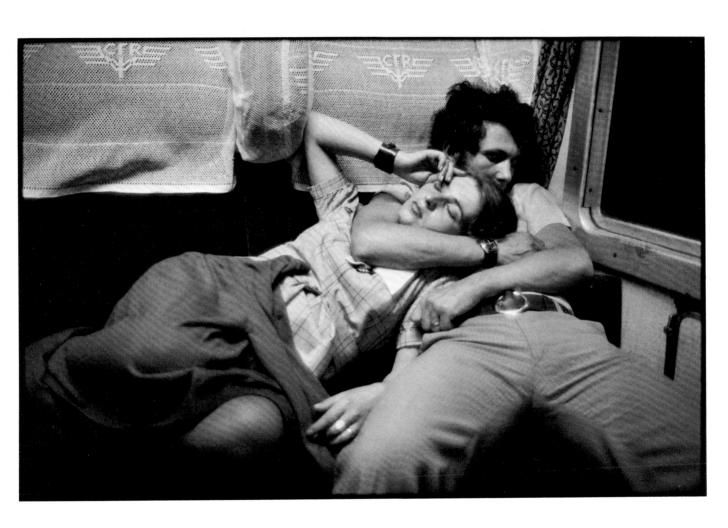

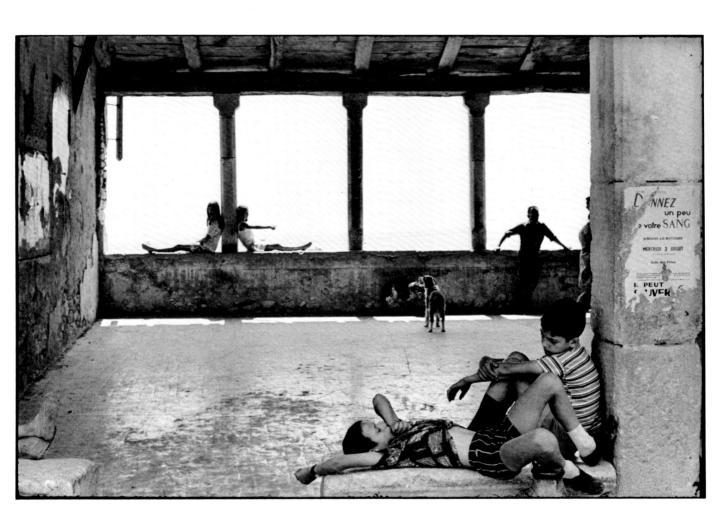

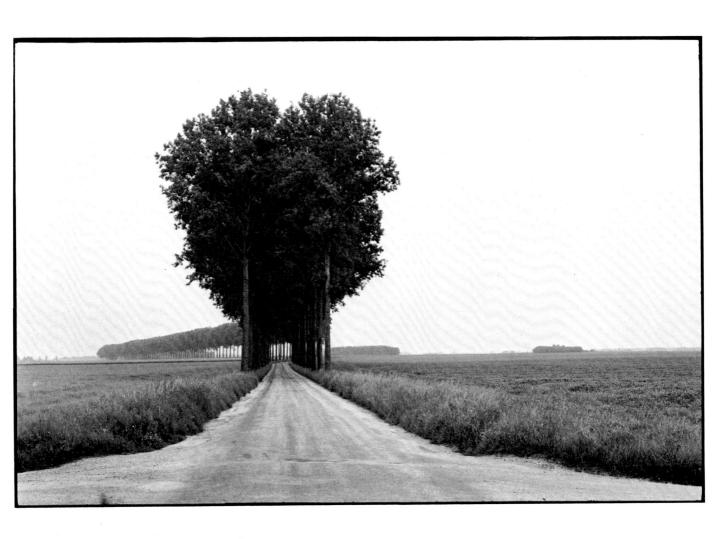

"Form is the base brought to the surface."
—VICTOR HUGO

PHOTOGRAPHS

Front cover: Seville, Spain, 1933

Frontispiece: New England, U.S.A., 1947

- 9. Córdoba, Spain, 1933
- 11. Taxi drivers, Berlin, 1932
- 13. Marseilles, 1932
- 15. Brussels, 1932
- 17. Seville, Spain, 1933
- 19. Seville, Spain, 1932
- 21. Alicante, Spain, 1932
- 23. Madrid, 1933
- 25. Arena at Valencia, Spain, 1933
- 27. By the Marne River, 1938
- 29. Barrio Chino, Barcelona, Spain, 1933
- 31. Quai Saint-Bernard, Paris, 1932
- 33. Mexico, 1934
- 35. Quai de Javel, Paris, 1932
- 37. Valencia, Spain, 1933
- 39. Behind the Saint-Lazare station, Paris, 1932
- 41. Trieste, Italy, 1933
- 43. Irène and Frédéric Joliot-Curie, Paris, 1945
- 45. Cardinal Pacelli at Montmartre, Paris, 1938
- 47. In a deportee camp, a Gestapo informer is recognized by a woman she has denounced: Dessau, Germany, 1945
- 49. The Berlin Wall, 1963

- 51. Hyde Park, London, 1938
- 53. Trafalgar Square on the day George VI was crowned: London, 1938
- 55. At the Curragh race course near Dublin, 1955
- 57. Henri Matisse, Vence, 1944
- 59. Pierre Bonnard, Le Cannet, 1944
- 61. Cafeteria of the workers' building, the Hotel Metropol, Moscow, 1954
- 63. The last days of the Kuomintang, Peking, 1949
- 65. Eunuch of the imperial court of the last dynasty, Peking, 1949
- 67. Srinagar, Kashmir, 1948
- 69. Gymnastics in a refugee camp at Kurukshetra, Punjab, India, 1948
- 71. Ahmedabad, India, 1965
- 73. William Faulkner, Oxford, Mississippi, 1947
- 75. Volcano of Popocatepetl, Mexico, 1964
- 77. Midnight Mass at Scanno in the Abruzzi, Italy, 1953
- 79. Funeral of a Kabuki actor, Japan, 1965
- 81. Cell in a model prison in the U.S.A., 1975
- 83. Rumania, 1975
- 85. Simiane la Rotonde, 1970
- 87. In Brie, France, June 1968
- 95. Salerno, Italy, 1933

BRIEF CHRONOLOGY

- **1908.** Henri Cartier-Bresson is born on August 22 at Chanteloup, Seine & Marne.
- **1922–23.** Attends the école Fénelon and the lycée Condorcet; no diplomas; develops a passionate interest in painting, and once a week studies with Cottenet.
- 1927-28. Studies painting with André Lhote.
- **1931.** Spends a year on the Ivory Coast; takes up photography upon returning to Europe.
- **1932.** His first works are exhibited at the Gallery Julien Levy, New York; then presented by Ignacio Sanchez Mejias and Guillermo de Torre at the Club Atheneo in Madrid.
- **1934.** As photographer joins an ethnographic expedition to Mexico.
- **1935.** Resides in the United States; studies motion pictures with Paul Strand.
- **1936 and 1939.** Assists director Jean Renoir, with Jacques Becker and André Zvoboda.
- **1937.** Films a documentary on hospitals in Republican Spain—*Victoire de la vie*.
- **1940.** Is taken prisoner by the Germans; manages to escape after two vain attempts.
- **1943.** Is active in the MNPGD, a clandestine movement to help prisoners and escapees; does portraits of artist, painters and writers (Matisse, Bonnard, Braque, Claudel, among others) for the publisher Braun.
- **1944–45.** Joins a group of professionals who photograph the occupation of France and the liberation of Paris; shoots *Le retour*, a documentary on the homecoming of prisoners of war and the deported.
- **1946.** Returns to the United States to complete a "posthumous" exhibition which the Museum of Modern Art in New York began in the mistaken belief that he had disappeared in the war.

- **1947.** Founds the cooperative agency Magnum with Robert Capa, David Seymour (Chim), and George Rodger.
- **1948–50.** Spends three years in the Orient, particularly in India, Burma, Pakistan, China (during the last six months of the Kuomintang and the first six of the People's Republic) and Indonesia (at the moment of its independence).
- 1952-53. Works in Europe.
- **1954.** Becomes the first photographer to be admitted to the Soviet Union after the end of the Stalin era.
- **1958–59.** Returns to China for three months on the occasion of the tenth anniversary of the People's Republic.
- **1960.** Undertakes reportage in Cuba; returns to Mexico for four months; travels to Canada.
- 1965. Lives for six months in India and three in Japan.
- **1966.** Leaves Magnum, but agrees to let the agency distribute his photographs to the press.
- **1969.** Spends a year preparing an exhibition to be held at the Grand Palais in 1970—"En France"; films two documentaries for CBS News.
- **Since 1973.** Concentrates on drawing, but takes photographs occasionally.

Honors conferred upon Henri Cartier-Bresson

Four Overseas Press Club awards: in 1948, for his reportage on the death of Gandhi; in 1954, 1960 and 1964, for the best reportage of the year, respectively on Russia, China and Cuba.

Honorary degree of Doctor of Letters, Oxford, 1975. Prix de la Société française de Photographie.

Prix de la Culture de la Société allemande de Photographie.

SELECTED BIBLIOGRAPHY

- **1947.** The Photographs of Henri Cartier-Bresson. A monograph published by the Museum of Modern Art of New York. Introduction by Lincoln Kirstein and Beaumont Newhall.
- **1952. Images à la sauvette.** Text and photos by Henri Cartier-Bresson. Cover by Matisse. Work conceived and executed by Tériade. Éditions Verve, Paris. American edition: *The Decisive Moment.* Simon & Schuster, New York.
- **1954.** Les danses à Bali. Text on the Balinese theater by Antonin Artaud and commentary by Beryl de Zoete. Delpire Éditeur, Paris. German edition: *Bali, Tanz und Theater*. Roven Verlag Olten, 1960.
- **D'une Chine à l'autre.** Preface by Jean-Paul Sartre. Delpire Éditeur, Paris. German edition: *China gestern und heute.* 1955. American edition: *From One China to Another.* Text by Han Suyin. Universe Books, New York, 1956. English edition: *China in Transition.* Text by Han Suyin. Thames & Hudson, London, 1956.
- **1955.** Les Européens. Photos and introduction by Henri Cartier-Bresson. Cover by Joan Miró. Work conceived and executed by Tériade. Éditions Verve, Paris. American edition: *The Europeans*. Simon & Schuster, New York.
- Moscou, vu par Henri Cartier-Bresson. Delpire Éditeur, Paris. German edition: Menschen in Moskau. Karl Rauch Verlag GmbH, Düsseldorf. American edition: People of Moscow. Simon & Schuster, New York. English edition: People of Moscow. Thames & Hudson, London. Italian edition: Mosca. Artimport, Milan.
- **1958.** Henri Cartier-Bresson: Fotografie. Text by Anna Farova. Photos by Henri Cartier-Bresson, layout by Ropert Delpire. Statni nakladatelstvi krasne literatury hudby a umenu, narodni podnik, Prague. A Slovak edition was published in Bratislava in 1959.
- **1963.** Photographies de Henri Cartier-Bresson. Delpire Éditeur, Paris. American edition: *Photographs*

- by Cartier-Bresson. Introduction by Lincoln Kirstein and Beaumont Newhall. Grossmann, New York. English edition: Jonathan Cape, London. Japanese edition: Asahi, Tokyo. German language edition: Cartier-Bresson Meister-Aufnahmen. Fretz & Wasmuth Verlag A.G., Zurich, 1964.
- **1964.** China. Photos and notes on 15 months spent in China. English edition by Barbara Brakeley-Miller. Bantam Gallery, New York.
- **1966.** The Galveston That Was. Text by Howard Barstone. Photos by Ezra Stoller and Henri Cartier-Bresson, Macmillan, New York, and the Museum of Fine Arts, Houston.
- **Photographs by Cartier-Bresson.** Introduction by Claude Roy and Ryoichi Kojima, Asahi Shimbum, Tokyo.
- **1968.** L'homme et la machine. Photos by Henri Cartier-Bresson, preceded by an introduction by Étiemble. Work executed under the auspices of IBM, Éditions du Chêne, Paris. American edition: *Man and Machine*. Viking Press, New York. English edition: *Man and Machine*. Thames & Hudson, London.
- Flagrants délits. Delpire Éditeur, Paris. American edition: The World of Henri Cartier-Bresson. Viking Press, New York. German language edition: Meine Welt, von Henri Cartier-Bresson. Verlag Bücher, Lucerne and Frankfurt.
- **Impressions de Turquie.** Booklet made for the Turkish Tourist Office, with an introduction by Alain Robbe-Grillet.
- 1970. Vive la France. Text by François Nourissier. Photos by Henri Cartier-Bresson. Published by Selection du Reader's Digest, Robert Laffont, Paris. American edition: Cartier-Bresson's France. Viking Press, New York. English edition: Cartier-Bresson's France. Thames & Hudson, London. German language edition: Frankreich. Verlag Bücher. Lucerne and Frankfurt.

1972. The Face of Asia. Introduction by Robert Shaplen. Published jointly by John Weatherhill (New York and Tokyo) and Orientations, Ltd. (Hong Kong). French edition: *Visage d'Asie*. Éditions du Chêne, Paris.

1973. A propos de l'U.R.S.S. Éditions du Chêne, Paris. American edition: *About Russia*. Viking Press, New York. English edition: *About Russia*. Thames & Hudson, London, German language edition: *Sowjetunion, photographische Notizen von Henri Cartier-Bresson*. Verlag Bücher, Lucerne and Frankfurt.

The Decisive Moment: Henri Cartier-Bresson. Audio-visual teaching material (set of photos and interview) published in the collection *Images of Man*. Scholastic Magazines, New York.

1979. Henri Cartier-Bresson, Photographer. Text by Yves Bonnefoy. Delpire, Paris.

1985. Photo Portraits. Thames and Hudson.
1986. Henri Cartier-Bresson: Les Cahiers de la Photographie. Contejour, Paris.

Articles (selected from numerous others) on Henri Cartier-Bresson

Beaumont Newhall, "The instant vision of Henri Cartier-Bresson." *Camera* (October, 1955)

Yvonne Baby, "'Le dur plaisir' de Henri Cartier-Bresson." *L'Express* (June, 1961).

Bob Schwalberg, "Henri Cartier-Bresson Today." *Popular Photography* (May, 1967).

Ernst Haas, "Henri Cartier-Bresson: A Lyrical View of Life." *Modern Photography* (November, 1971).

Lincoln Kirstein, "Metaphores of motion." *The Nation* (March, 1971).

Claude Roy, "Ce cher Henri." Photo (November, 1974).

Hilton Kramer, The New York Times (July 7, 1968; February 7, 1971; and March 1, 1975)

Cecil Beaton, "Henri Cartier-Bresson" *The Magic Image* (Little Brown and Co, Boston, 1975)

Roger Clark, "The Sad Fate of Henri Cartier-Bresson." The British Journal of Photography (May 30, 1980).

MAJOR EXHIBITIONS

Photographs

1932. The Gallery Julien Levy, New York (first exhibition); The Cercle Atheneo, Madrid.

1934. With Manuel Alvarez Bravo: The Palacio de Bellas Artes, Mexico.

1935. With Walker Evans: The Gallery Julien Levy, New York.

1947. The Museum of Modern Art, New York ("posthumous" exhibition).

1948. Bombay.

1952. The Institute of Contemporary Arts, London.

1953. Florence.

1955. The Musée des Arts Décoratifs, Paris (first large exhibition: 400 photos). (This exhibition traveled to various museums in Europe, then, under the auspices of the American Federation of Art, to the United States and Canada; in Japan, it was presented by Mainichi.)

1964. The Phillips Collection, Washington.

1965. Tokyo (second retrospective show, presented by Asahi). (This exhibition then went to the Musée des

Arts Décoratifs, Paris, 1966–67, under the patronage of André Malraux and with the collaboration of Robert Delpire; to the Museum of Modern Art, New York, 1968; to the Victoria and Albert Museum, London, 1969; to the Stedelijk Museum, Amsterdam; to Rome, where it was organized by Balthus; to Zurich, Leverkusen, Hamburg, Bremen, Munich, Milan, Cologne, Aspen.)

1970. "En France": the Grand Palais, Paris (This exhibition of 150 photos traveled throughout France until 1976. It has also been shown in the United States, at the Gallery Hallmark, New York, 1970; in the Soviet Union, at the Manège Museum, Moscow, 1972; in Yugoslavia, at the Museum of Modern Art, Belgrade, 1973; in Australia and in Japan, 1974.)

1974. The International Center of Photography, New York (exhibition on Russia: 1953–1974).

1975. The first international Triennial of photography presented by Michel Terrapon Fribourg, Switzerland.

1978. Fruit Market Gallery, Edinburgh (and Side Gallery, Newcastle-upon-Tyne).

1979. International Center of Photography, New York (retrospective; toured the United States, 1979–82).

Galerie Delpire, Paris.

1985. International Center of Photography, New York (portraits).

1987. Museum of Modern Art, New York (photographs made up to and including his trip to Mexico in 1934).

Drawings

1975. The Carlton Gallery, New York (first exhibition).

1976. (Summer) The Gallery Lucien Henri, Forcalquier, Alpes de Haute-Provence.

1987. Arnold Herstand Gallery, New York.

FILMS

Assistant to Jean Renoir in 1936 for La vie est à nous and Une partie de campagne, and in 1939 for La règle du jeu. Henri Cartier-Bresson is sole author of:

1937. Victoire de la vie. Documentary on hospitals in Republican Spain, with Jacques Lemare as cameraman. Music from Charles Koechlin.

1944–45. Le retour. Documentary on the homecoming of prisoners of war and deportees. Produced by the OWI and the Ministry of Prisoners, directed by Henri Cartier-Bresson, Lt. Banks and Capt. Krimsky, and produced by Norman Ratner.

1969–70. Two documentaries for CBS News: **Impressions of California,** with Jean Boffety as cameraman, **Southern Exposures,** with Walter Dombrow as cameraman.

Films made from stills by Henri Cartier-Bresson

1963–64. Five 15-minute films on Germany for the Süddeutscher Rundfunk. Munich.

1963. Midlands at Play and at Work. For ABC Television, London.

1964. Quebec. For the Canadian Film Board.

1967. Flagrants délits. On Henri Cartier-Bresson's work. By Robert Delpire. A Delpire production, Paris.

1970. Images de France. By Liliane de Kermadec for O.R.T.F. An Unite Trois production.

1975. Why New Jersey. For WNET, New York.

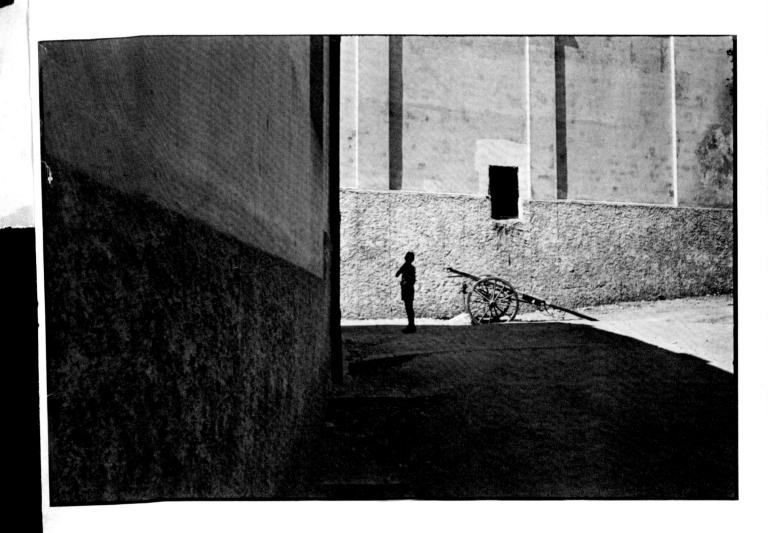